The Three Graces

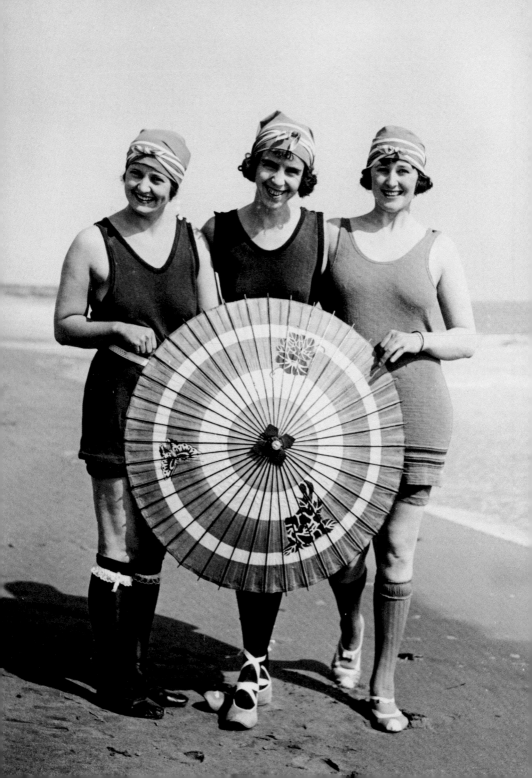

The Three Graces

SNAPSHOTS OF TWENTIETH-CENTURY WOMEN

Michal Raz-Russo

YALE UNIVERSITY PRESS
NEW HAVEN AND LONDON
IN ASSOCIATION WITH
THE ART INSTITUTE OF CHICAGO

This book was published to coincide with the exhibition
The Three Graces, organized by the Art Institute of Chicago,
October 29, 2011–January 22, 2012.

Support is provided by the Saul and Devorah Sherman Fund.

yalebooks.com

Library of Congress Cataloging-in-Publication Data

Raz-Russo, Michal.
 The three graces : snapshots of twentieth-century women / Michal
Raz-Russo.
 p. cm.
 Includes bibliographical references.
 ISBN 978-0-300-17734-3 (hardback)
1. Photography of women—Exhibitions. 2. Portraits, Group—
Exhibitions. 3. Art Institute of Chicago—Photograph collections—
Exhibitions. 4. Photograph collections—Illinois—Chicago—Exhibitions.
I. Title.
 TR681.W6R39 2011
 779'.24—dc23 2011014921

A catalogue record for this book is available from the British Library.
This paper meets the requirements of ANSI/NISO Z39.48-1992
(Permanence of Paper).
10 9 8 7 6 5 4 3 2 1

Printed in Singapore by CS Graphics
Designed by Miko McGinty, Inc.

Frontispiece: c. 1920s
Cover illustrations: Snapshots from *The Three Graces* collection and
exhibition, the Art Institute of Chicago

CONTENTS

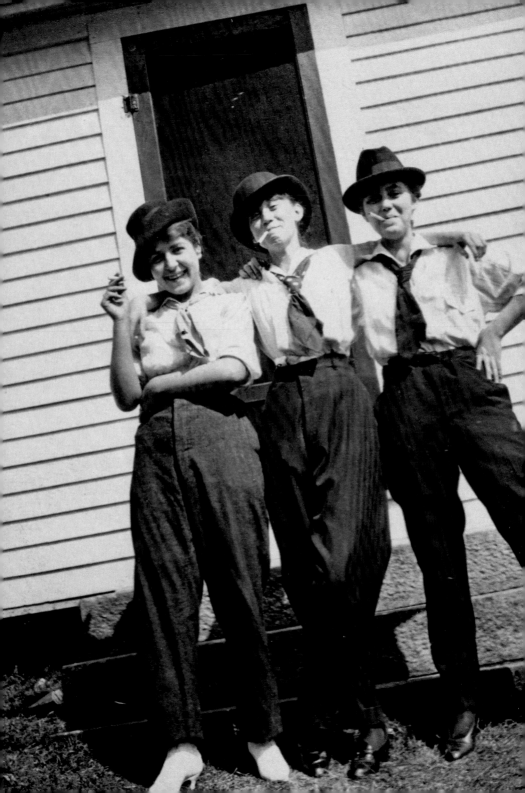

Not Their Mothers' Snapshots

On the back of a snapshot of three charming ladies playfully peeking from behind a hedge, a remnant of album paper is inscribed with the phrase "Look pleasant" (fig. 1; p. 19). This charge echoes the professional photographer's directive to individuals as they prepared for the immortalizing click of the shutter: to pause and pose for the camera.[1] The convention of putting on a cheerful and spirited expression in photographs became common at the turn of the twentieth century as snapshots became increasingly associated with fun and leisure activities.[2] Yet a treasure trove of photographs featuring three women posing together, a selection of which is collected in this book, tells a more complex story about the event of taking a snapshot. The women in these images display much more than mere pleasantness; their engagement with the camera is playful, sultry, and even provocative. The formal and behavioral conventions charted

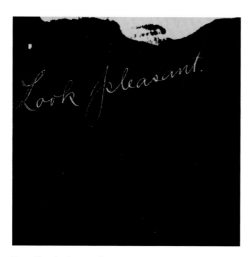

Fig. 1. "Look pleasant," c. 1910s

here reveal how generational changes and cultural influences shaped women's self-presentation in front of the camera in the first half of the twentieth century.

A photographer snaps a picture with the intention of keeping or displaying it alongside other snapshots. These images of celebrations, vacations, and gatherings of family and friends are accumulated with the aim of constructing a personal identity and preserving it for future generations. Beyond their individual capacity to preserve and evoke memories, personal photographs function as archival documents that, over time, demand to be scrutinized and measured against one another—to see how someone has aged, discern whether she resembles other family members, and trace how she lived her life. But what happens when these same photographs are discarded or displaced, removed from private albums and shoeboxes, and become merely *anonymous*? At this moment they are transformed into cultural artifacts that collectively reveal a great deal about the evolving ritual of self-presentation before the camera.

Stripped of their provenance and surrounding narratives, the snapshots presented here can be assessed only as historical or aesthetic objects against the visual information captured within the four edges of the photograph and, in some cases, the inscriptions scrawled on the back of the prints. Dating from the 1910s to the 1960s, and largely of American origin, these photographs span the decades during which photography skyrocketed in popularity among amateurs and the handheld film camera saw significant technical advances.[3] The majority of these snapshots were presumably taken by nonprofessionals, sent away or dropped off at the drugstore for processing, and later placed in albums or frames. These now disowned and scattered photographs were plucked from flea markets, shops, and galleries by Peter J. Cohen, a collector who was captivated by their eclectic and yet familiar details. Cohen, whose collections are vast, has divided his snapshots according to type. One of these, from which the pictures included here are drawn, encompasses more than five hundred snapshots featuring trios of women. Cohen discerningly named them after an iconic Greco-Roman motif, the Three Graces.[4]

In traditional western iconography, the Three Graces—commonly identified as the Greek muses Aglaia, Euphrosyne, and Thalia—personify beauty, charm, and grace in both nature and humanity. Together, they are believed to bestow pleasure and prosperity while encouraging both the giving and receiving of goodwill.[5] The Greeks rendered the trio of muses as individual figures, each with distinctive identities and gestures. In the hands of the Romans, however, the Graces assumed a standardized pose and composition, regardless of context or medium: two figures face forward while the third turns in the opposite direction. The three embrace each other as if caught mid-dance, with emphasis placed first and foremost on the unity of the group and their form (fig. 2).[6] In the centuries since antiquity, the motif of three women has been reproduced in everything from frescoes to films and has been continuously adapted to fit popular as well as fine art contexts. In the snapshots assembled here, the trios of women posing for the camera—in varied settings and over a period of more than fifty years—all project remarkably uniform confidence and poise. The consistency of their assuredness prompts a game of compare and contrast to reveal the influence of popular notions of beauty and

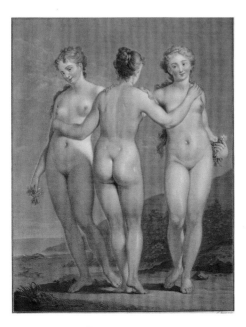

Fig 2. Jean François Janinet, *The Three Graces*, c. 1786. Color engraving on paper. The Art Institute of Chicago, gift of the Estate of Mrs. Potter Palmer, 1956.356.

style. Indeed, the women in these images do seem to embrace the historical characterization of the Three Graces, each pursuing her own individual state of grace in front of the photographer.

The arrival of the snapshot in the late nineteenth century prompted radical transformations in the subjects and look of personal photographs. The origin of the snapshot can be traced to 1888, when George Eastman (American, 1854–1932) began marketing the Kodak #1, a rudimentary box camera that came preloaded with a 100-exposure roll of film. Eastman Kodak Company soon introduced more affordable cameras, such as the Brownie (1900), which, along with offerings by competitors, made snapshot photography accessible and immensely popular.[7] Further, Kodak's slogan, "You press the button, we do the rest," underscored the idea that anyone could take a photograph.

As handheld cameras became popular, many snapshooters looked to images by serious amateurs and professional photographers for guidance in creating a "good" or "proper" photographic composition. Trade publications launched around this time provided a wealth of advice for hobbyists on topics such as lighting, film processing, and—notably—composing a group photograph. A 1907 issue of *The Amateur Photographer* includes counsel for those photographing more than two sitters: "Of course, the very last thing a photographer requires of his group is that the members of it shall look as if they were being photographed. . . . They should appear to have some interest in each other, instead of showing the consciousness of the photographic ordeal all over their faces and figures."[8] The author of this article, Carine Cadby, asserts that achieving a natural pose in a group photograph requires skill and experience, hinting that the perfect snapshot might be constructed rather than merely caught by chance. This understanding of the staged nature of snapshot photography was echoed in French sociologist Pierre Bourdieu's observation that the "'natural' is a cultural ideal which must be created before it can be captured."[9] Although trade publications such as *The Amateur Photographer* invited consumers to engage in serious experiments, they had little impact on popular approaches to snapshooting. Ultimately, the combination of

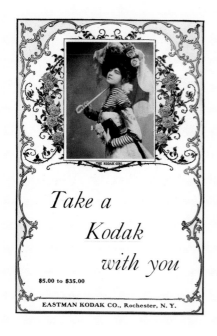

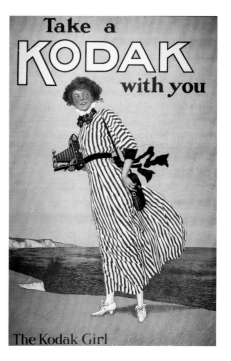

Fig 3a. *Take a Kodak with You,* advertisement, June 1901. Courtesy of George Eastman House, International Museum of Photography and Film.

Fig 3b. *Take a Kodak with You,* advertisement, c. 1913. Courtesy of George Eastman House, International Museum of Photography and Film.

clever marketing and technical innovations paved the way for the camera to be regarded as an indispensable tool for documenting modern life.

Snapshooters embraced leisure play and everyday family life as favorite subjects just as lighter equipment and faster shutter speeds allowed for easy, casual, and carefree picture-taking. Camera companies, specifically Eastman Kodak, seized on this correlation in their advertisements, which were immensely influential in defining what should be photographed and by whom. The introduction of the young and stylish "Kodak Girl" in 1893 targeted women as both photographers and subjects, encouraging them to regard snapshot photography, as cultural historian Nancy Martha West notes, as a "practice akin to fashion—as an activity that could enable them to constantly remake the images that purported

to represent their lives, just as clothes allowed them to constantly remake their self-image, into objects of desire."[10] The Kodak Girl's ease and style also encouraged a woman to embrace the simplicity and sentimentality of snapshot photography as one of her domestic duties. Advertisements that featured the Kodak Girl encouraged women to "Take a Kodak with you," "Kodak as you go," and "Keep a Kodak Story" (figs. 3a–b). These charges appealed to a growing consumer culture that began to take shape in the late nineteenth century. Within this culture the camera had to be on hand not only to capture what people looked like, but also to tell the story of how they lived their lives in a new modern era. As a new century ushered in increasing independence and power for women, they not only picked up a camera but also took up the representation of their own identity.

The Kodak Girl likely owed a great deal to another popular icon introduced in 1890: the Gibson Girl (fig. 4).[11] With her exaggerated hourglass figure, loose chignon, and delicate features, the Gibson Girl became a modern-day muse, the personification of a new femininity and youthful

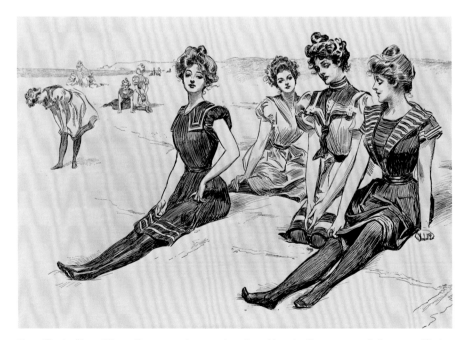

Fig. 4. Charles Dana Gibson, *Picturesque America, Anywhere Along the Coast*, c. 1900. © Bettmann/Corbis.

élan as imagined by the illustrator Charles Dana Gibson (American, 1867–1944). Her fabricated image, which like that of the Kodak Girl was created for commercial purposes, represented the effortless—even carefree—grace that fashionable women hoped to project in front of the camera (p. 99). Perhaps more significantly, it also signaled the growing influence that popular media images had both on amateur photographers and on those caught in their pictures.

As luxuries like vacations, automobiles, fashion, and technology became increasingly available to the middle and working class, the practice of documenting those pleasures and accomplishments for posterity became routine. During the golden age of snapshot photography, it was common to pose in front of homes or cars, as such possessions confirmed a social status (pp. 52, 61). Rather than staying at home, these are women about to take to a walk in town, enjoy an evening out with their sweethearts, make a day trip with friends, or take a family vacation (pp. 37, 38). The emblems of status for these women represent departure points for a new generation. As embodiments of twentieth-century Graces, the women captured here represent the freedom and variety of modern life and the pursuit of leisure.

By the 1920s, vacationing in its many forms had become integral to the experience of the middle class. As experts advocated the benefits of rest, and as paid time off became increasingly common, people of all classes seized the opportunity to travel and let loose while away from their everyday routines.[12] Taking snapshots while partaking in recreational activities certified, as Bourdieu put it, "that one has had leisure and the leisure to photograph it."[13] Bringing home photographs of vacations, celebrations, and other momentous events became an expectation, proof of a good time had by all, including the person handling the camera.

Indeed, each of the snapshots presented here implicates a fourth person—the photographer—as a participant, not merely an inconspicuous observer of happy times. The gender of the snapshooter and any others present outside the photographic frame can be inferred by compelling—and often accidental—details. One image of three well-dressed ladies

out on the town inadvertently includes the facing shadows of two equally fashionable female companions, one of whom presumably held the camera (p. 140). In another, the tip of a man's shoe has sneaked into the right corner of the frame (p. 97). And in serial examples the photographers are fully revealed, as groups of women captured their adventures by taking turns with the camera to produce several matching exposures, giving each woman an opportunity to strike a memorable pose with the group (pp. 70, 71). When such clues are not readily available it can only be guessed, for example, that a candid snapshot of three sunbathers was taken by a male gawker (p. 77). Poses and expressions shared across these images—whether tomboy postures or come-hither smirks—affirm that the gender of the snapshooter had a profound effect, intentional or not, on women's performance in front of the camera (pp. 112, 146). Such details also evidence larger social changes taking place. Together these images reveal that regardless of who was taking the picture, women became increasingly aware of the transformative power of the snapshot.

The image of the modern woman underwent its first dramatic shift in the decade after World War I. As the war years had brought an unprecedented number of women into the workforce, and the right to vote was granted, the road was paved for women to construct an aspirational new image for themselves (p. 50). By the 1920s, raised hemlines, flattened bosoms, dropped waists, and closely cropped hair defined the young boyish look known as *La Garçonne* and later associated with the more feminine flapper (p. 45).[14] For these women, fashion served as a highly visible means to express a newly sought rebellious independence and to abandon the decorum imposed on a previous generation. Simultaneously, smaller cameras, faster film speeds, and automatic exposures allowed for increasingly spontaneous and informal snapshots. In images from this era and after, women appear more playful and assertive in front of the camera, as if to proclaim, "These are not our mothers' snapshots."

This bolder attitude seems to have persisted through the interwar years. Despite the onset of the Depression, many of the women in images dating

from the 1930s and 1940s appear remarkably cheerful and unaffected by economic hardship (pp. 42, 79).[15] The proliferation of weekly picture magazines, photographic advertisements, and art-world acceptance in these decades served to widen the appeal of photography for all.[16] Camera companies reminded consumers that in the worst economic times, snapshots were not a frivolous luxury but a crucial means by which to preserve memories for future generations. And indeed, during the Depression and the war years that succeeded it, snapshots functioned to edit life. For example, an image dated 1945 of three carefree women on the shore — with one wearing a military hat perhaps belonging to an off-duty male companion sitting nearby or behind the camera — represents the lighthearted interactions that occur even in wartime (p. 72). This photograph, taken as World War II neared its end, suggests that snapshots were used to document life as it should be remembered.

Surrounded by images generated by popular media, the women in these photographs take advantage of the snapshot's ability to shape and transform identities. Around the same time that photography became a ubiquitous part of life and especially during the years of World War II, Hollywood enjoyed an influential boom as moviegoing reached record numbers.[17] The escapist entertainment offered by such movies as *The Big Broadcast* (1932) and *Poor Little Rich Girl* (1936) portrayed the successful pursuit of happiness, romance, wealth, and fame. Across film, advertising, and emerging television markets, audiences were bombarded with idealized representations of everyday life. Snapshots were now the means by which to imitate the coveted identities in these appealing still and moving images. Female performers thus became muses, embodying ideals that women aspired to and men desired. Several photographs dating from the 1930s and 1940s recall the poses, compositions, and styles — whether consciously or not — of publicity shots of such famous trios as the Andrews Sisters, the Gumm Sisters, and the Boswell Sisters (figs. 5a–b; pp. 51, 53). These and other performers channeled a confident and adventurous spirit that women wanted to project in their lives. In Hollywood's shadow, this desire was reinforced with the emergence of two models of seductive

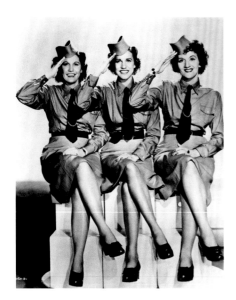

sexuality in the 1940s. The debut of Dior's hugely influential New Look in 1947, with its accentuated bust, cinched waist, and full skirts, ushered in an era of ladylike elegance. Concurrent with this celebration of an exaggerated but constrained feminine silhouette, the image of the pin-up girl—a term not commonly used until the early 1940s—enjoyed an explosion in popularity.[18] These ubiquitous yet seemingly incompatible representations of women combine in contemporaneous snapshots to produce predetermined and theatrical poses that demonstrate an overt sexuality, from a modest display of alluring legs to a glimpse of a playful striptease behind closed doors (pp. 75, 135).

Included among the snapshots in these pages are several erotic images that were presumably sold individually or in sets, many depicting women in domestic or outdoor settings (pp. 119–20, 125–27, 133–34). While these images from the 1940s and 1950s were likely commercially conceived, the evocative private settings of personal snapshots only heightened their allure. Some of these risqué photographs could have been taken by members of hobbyist camera clubs that often hired models. Such images emphasize not only the ongoing influence of popular media on the personal snapshot but also the blurring of boundaries

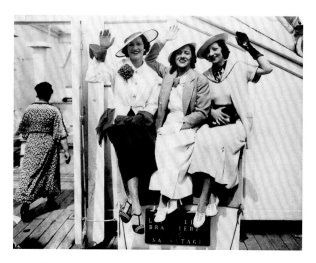

Fig 5b. The Boswell Sisters, *Radio Singers Sail on Île-de-France,* 1935.
© Bettmann/Corbis.

between images produced for mass consumption and those made among intimates. Like the discarded snapshots that make up this collection, the women in these erotic images remain anonymous, their poses and facial expressions demanding to be studied within the same social frameworks as the snapshots themselves.

Whether treasured, handed down, or found, snapshots cannot supply the information needed to fully reconstruct the context in which they were created. To be sure, the images presented here are a small sample of photographs of female trios and an infinitesimal selection of all snapshots taken of or by women. Each picture was chosen for a distinctive detail—a bold pose, an awkward expression, or a whimsical outfit—yet the theme of the Three Graces reveals unexpected overall similarities occasioned by cultural and generational influences. As a group they attest to the impact of popular photographic images on individual self-representation and to the tremendous influence that wielding a camera had on the way in which women saw themselves. As twentieth-century representations of the Three Graces, these women project beauty, charm, and grace, and like their classical counterparts they offer only fragments of stories, leaving much to the imagination.

Notes

1. An early critique and reference to this popular request is discussed in Sidney Allan, "The Control of Expression and Attitude," *Portrait: A Magazine Devoted to Art-in-Portraiture, also Profit-in-Photography and Committed to a "Square Deal,"* January 1916.

2. For more on the emergence of the smile in snapshots, see Christina Kotchemidova, "Why We Say 'Cheese': Producing the Smile in Snapshot Photography," *Critical Studies in Media Communication* 22, no. 1 (March 2005), pp. 2–25.

3. For historical overviews of these advances, see Sarah Greenough and Diane Waggoner, eds., *The Art of the American Snapshot, 1888–1978: From the Collection of Robert E. Jackson* (Princeton: Princeton University Press, 2007); Brian Coe and Paul Gates, *The Snapshot Photograph: The Rise of Popular Photography, 1888–1939* (London: Ash and Grant, 1977); Colin Ford, ed., *The Story of Popular Photography* (London: Century Hutchinson, 1989).

4. *The Three Graces* is only one among many snapshot typologies assembled and collected by Peter J. Cohen. Groups of snapshots titled *Dangerous Women, Cornfields,* and *About Face* are other examples of Cohen's typologies.

5. Elizabeth J. Milleker, "The Three Graces on a Roman Relief Mirror," *Metropolitan Museum Journal* 23 (1988), pp. 69–81; and Jane Francis, "The Three Graces: Composition and Meaning in a Roman Context," *Greece and Rome,* 2nd ser., 49, no. 2 (October 2002), pp. 180–98.

6. Francis, "Three Graces," pp. 191–93.

7. The Brownie retailed for $1, equivalent to approximately $25 today, according to the Consumer Price Index.

8. Carine Cadby, "A Chat About Groups," *The Amateur Photographer* 45, no. 1,168 (February 19, 1907), p. 164.

9. Pierre Bourdieu, *Photography: A Middle-Brow Art,* trans. Shaun Whiteside (Stanford: Stanford University Press, 1990), p. 81.

10. Nancy Martha West, "Proudly Displayed by Wearers of Chic Ensembles," in *Kodak and the Lens of Nostalgia* (Charlottesville: University of Virginia Press, 2000), p. 112.

11. Ibid., p. 117.

12. Cindy S. Aron, *Working at Play: A History of Vacations in the United States* (New York: Oxford University Press, 1999), pp. 183–236.

13. Bourdieu, *Photography,* p. 36.

14. Valerie Mendes and Amy de la Haye, *Fashion Since 1900,* 2nd ed. (London: Thames and Hudson, 1999), pp. 58–60.

15. It seems plausible that the snapshots represented in this collection were made by members of an economic class that could afford to continue snapping during the Depression, and not those most affected by economic hardships.

16. Sarah Kennel, "Quick, Casual, Modern: 1920–1939," in Greenough and Waggoner, *Art of the American Snapshot,* pp. 99–101.

17. Douglas Gomery, *Shared Pleasures: A History of Movie Presentation in the United States* (Madison: University of Wisconsin Press, 1992), pp. 34–82.

18. Mark Gabor, *The Pin-Up: A Modest History* (New York: Bell), p. 77.

Plates

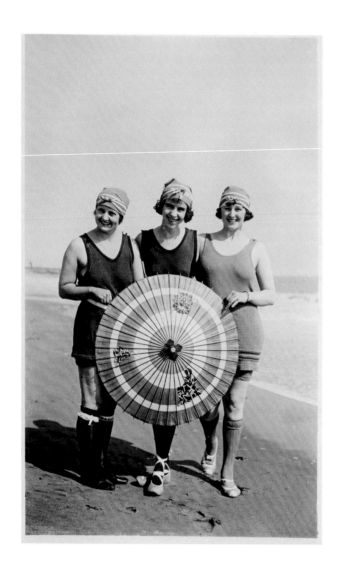

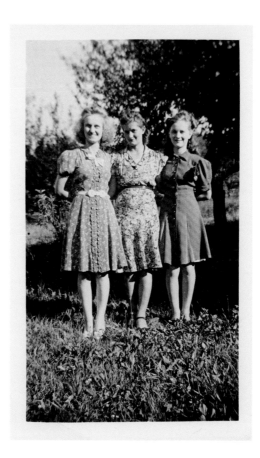

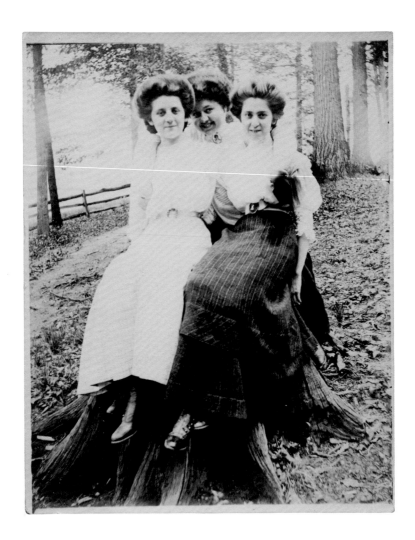

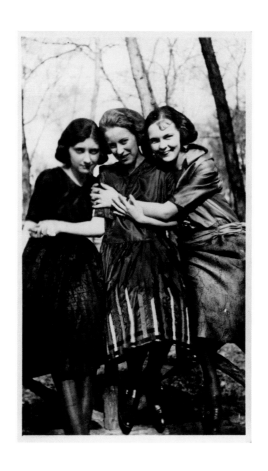

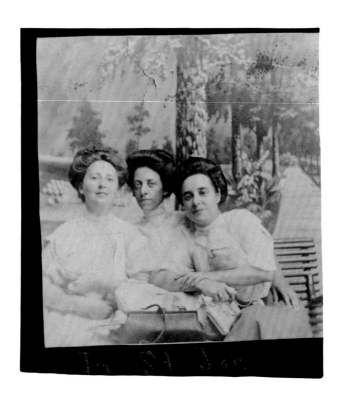

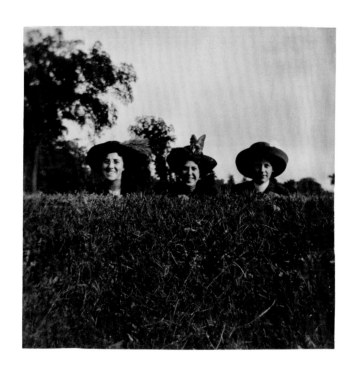

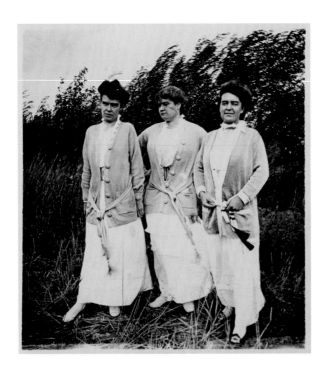

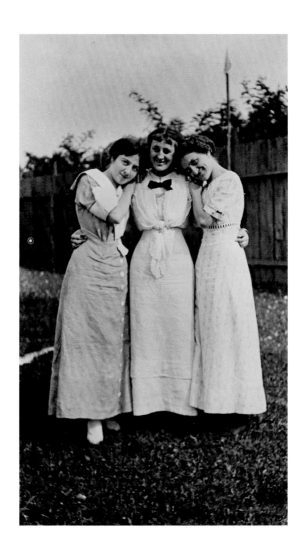

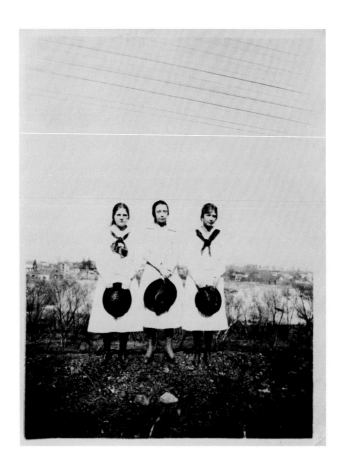

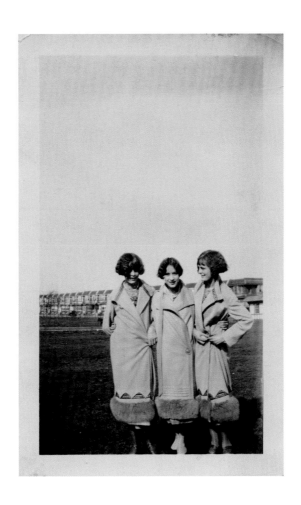

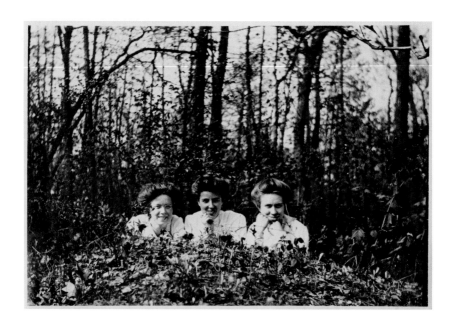

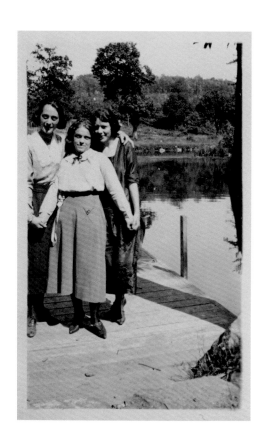

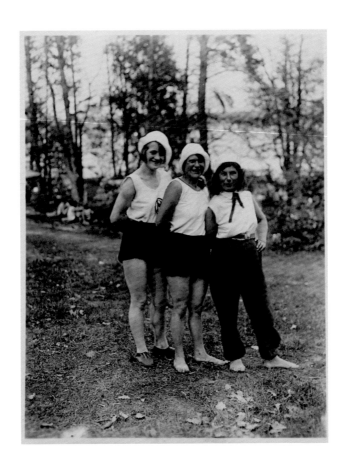

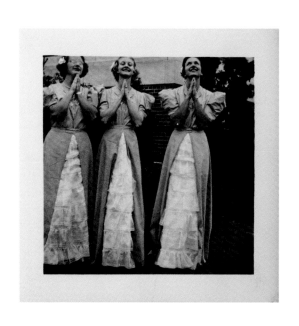

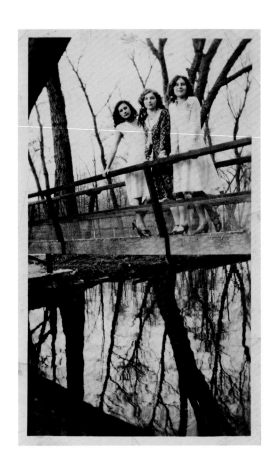

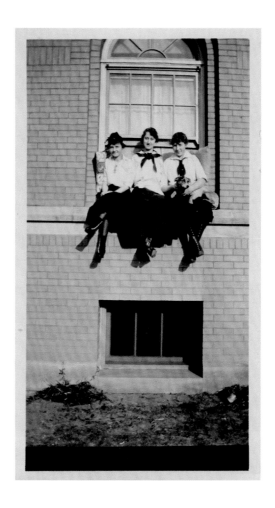

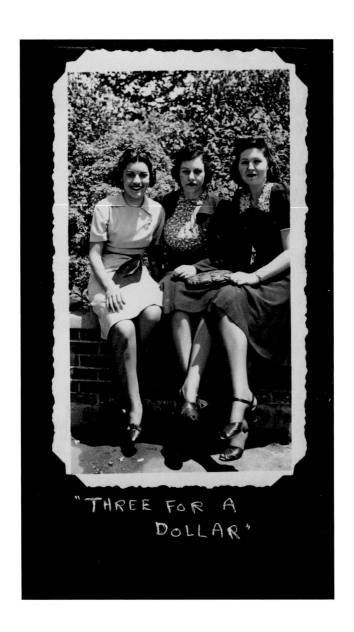

"THREE FOR A DOLLAR"

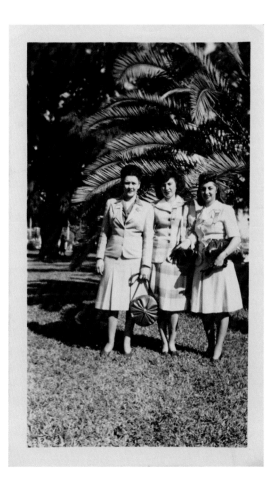

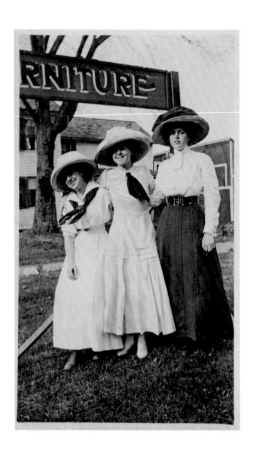

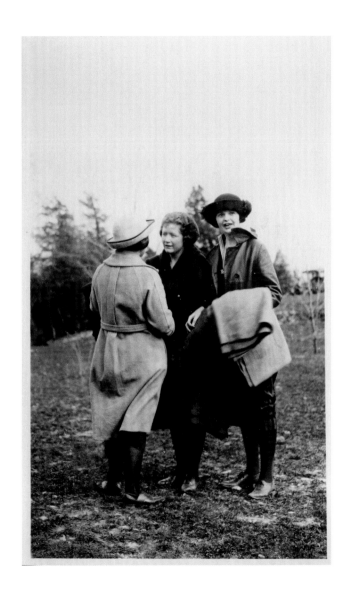

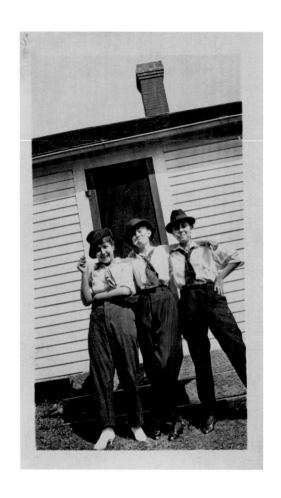

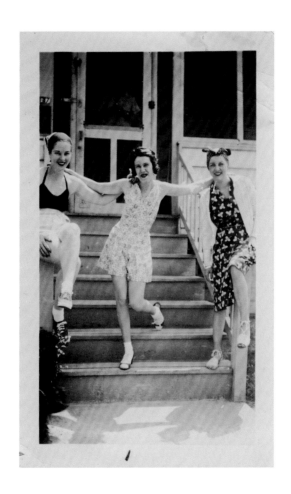

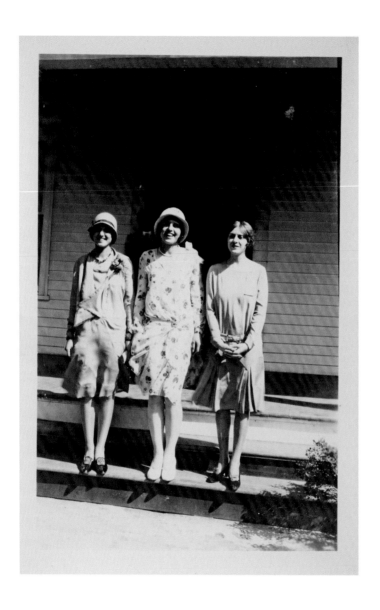

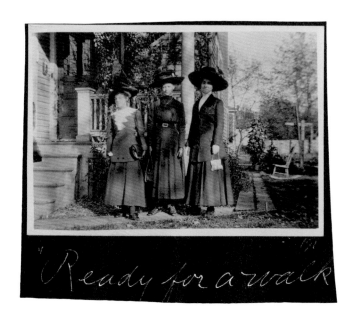

"Ready for a walk"

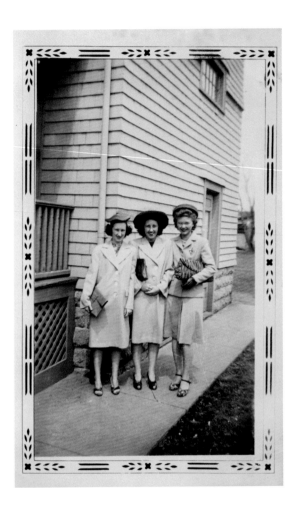

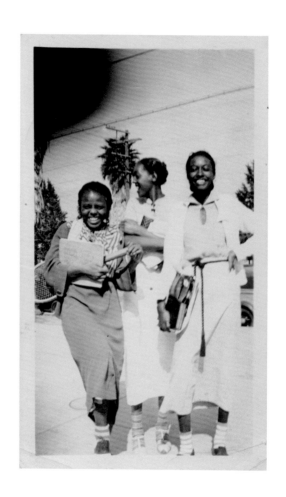

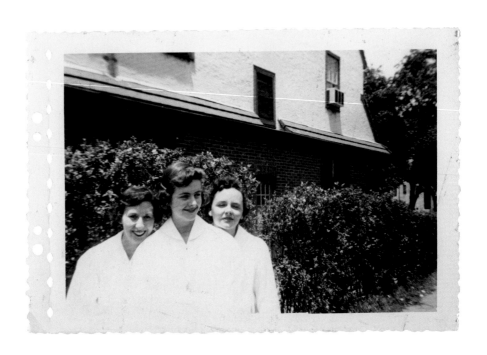

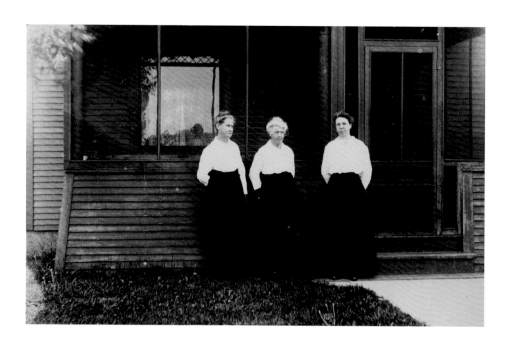

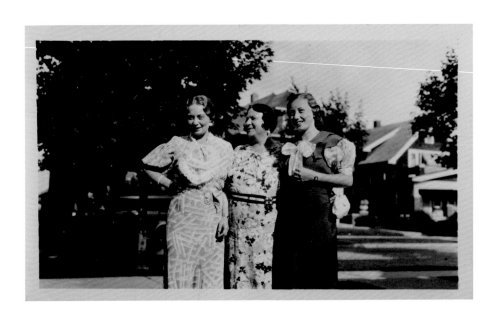

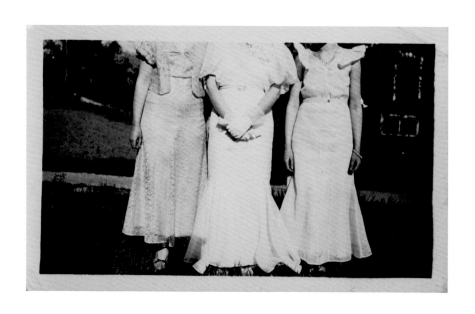

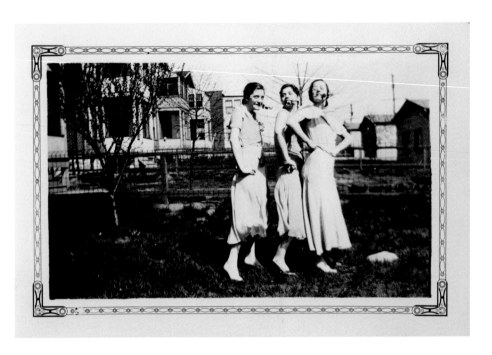

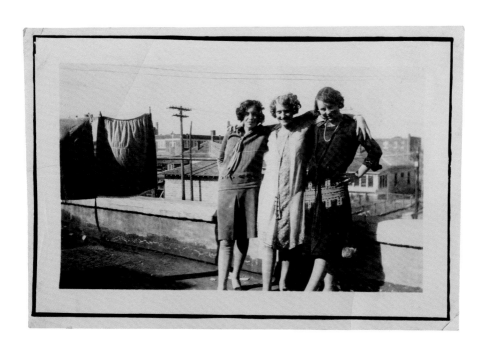

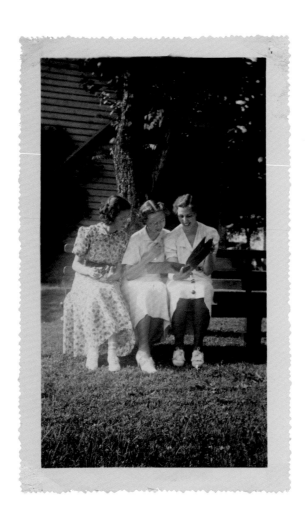

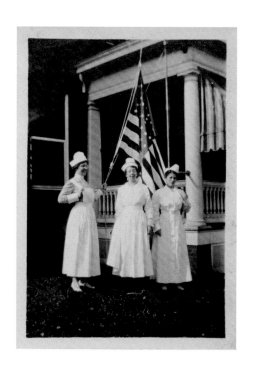

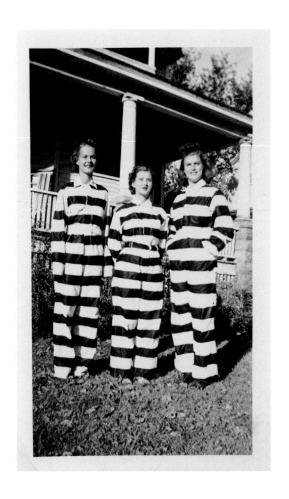

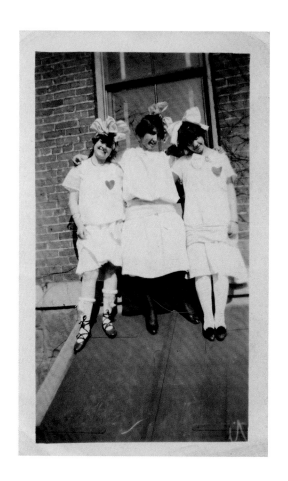

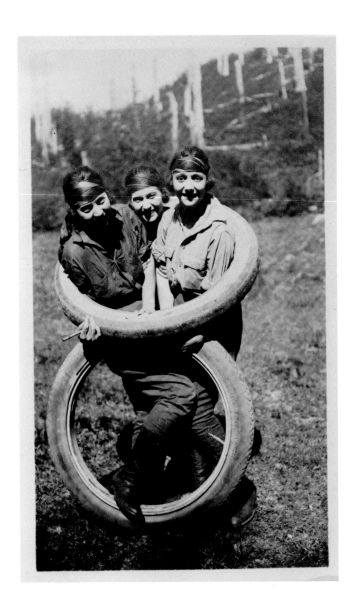

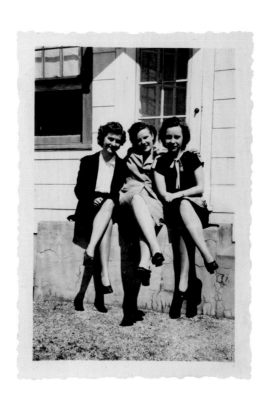

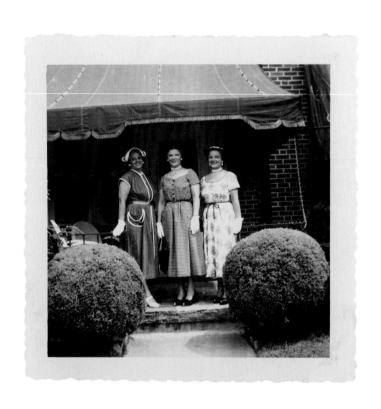

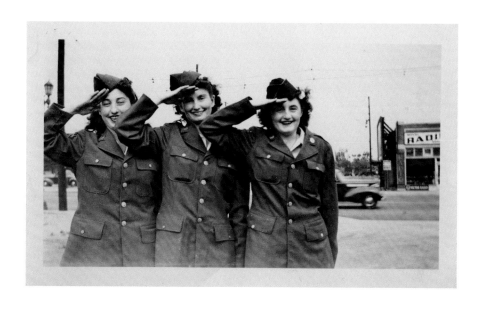

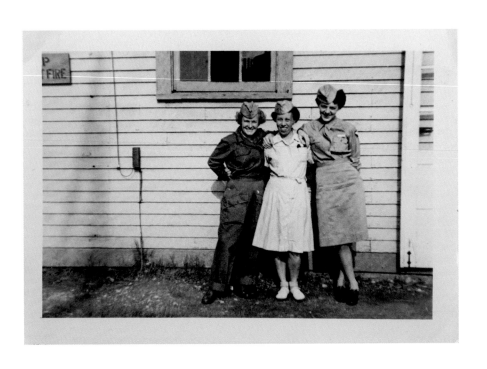

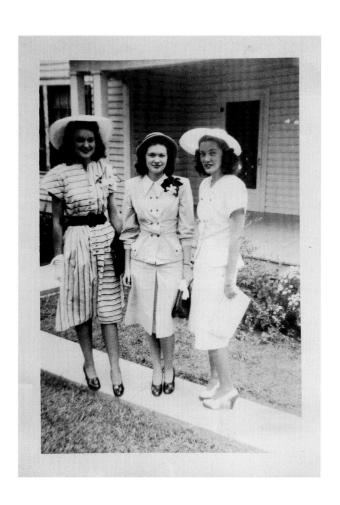

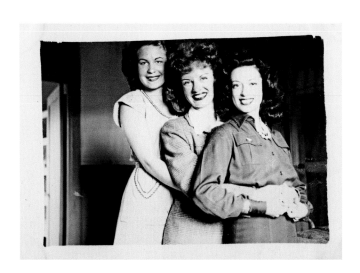

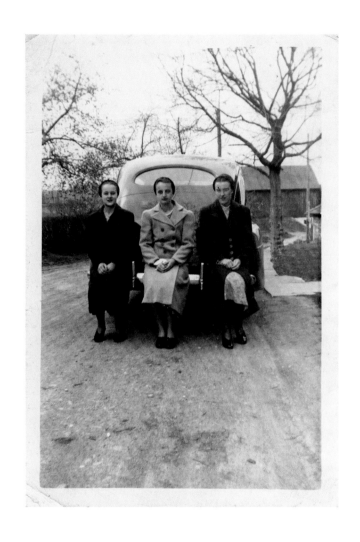

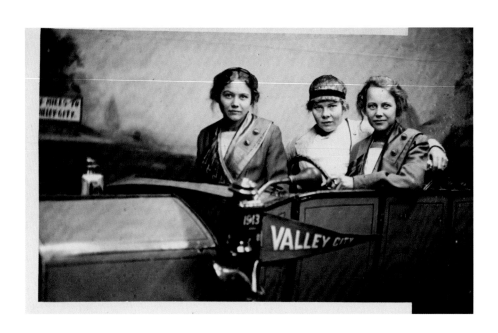

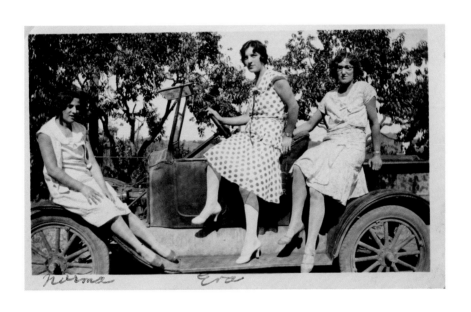

Norma Eva

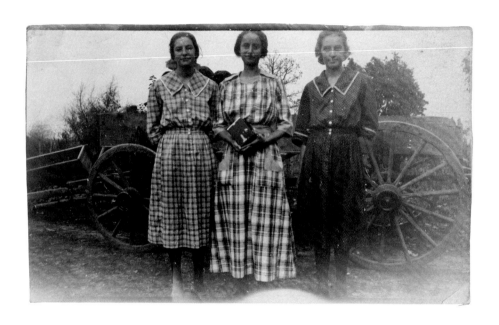

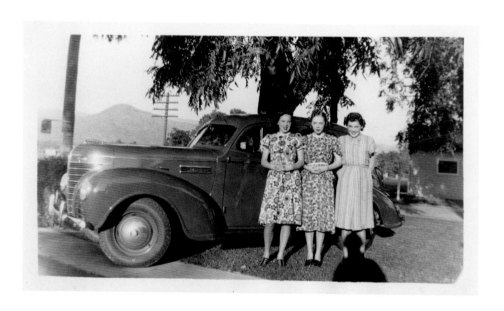

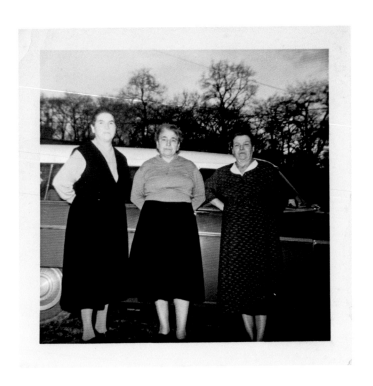

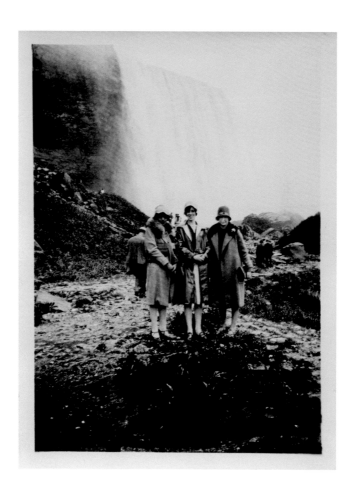

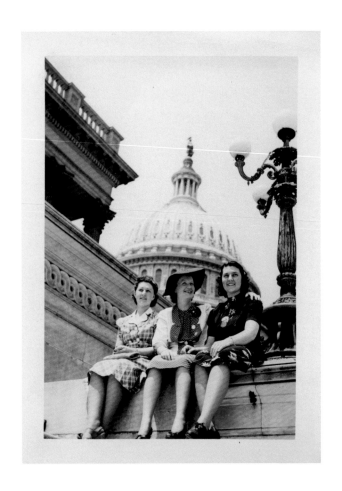

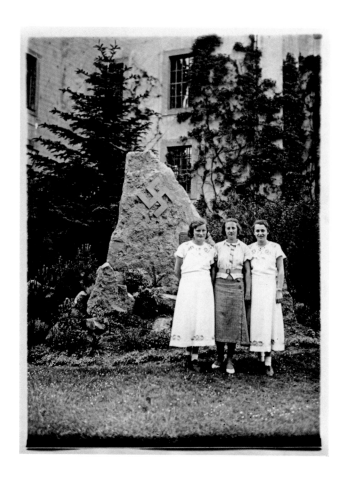

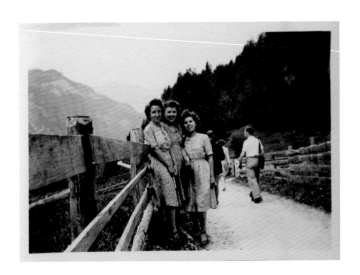

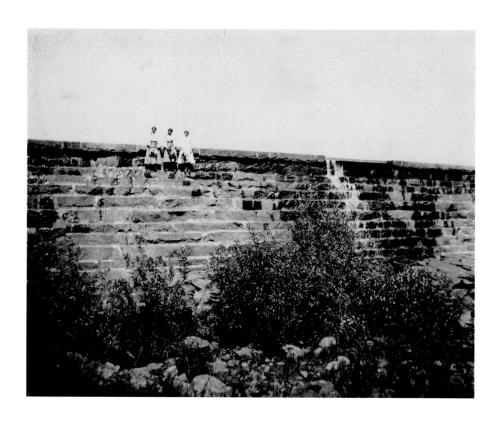

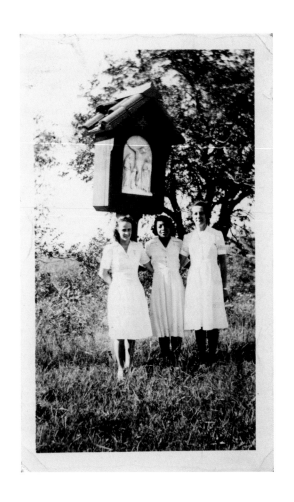

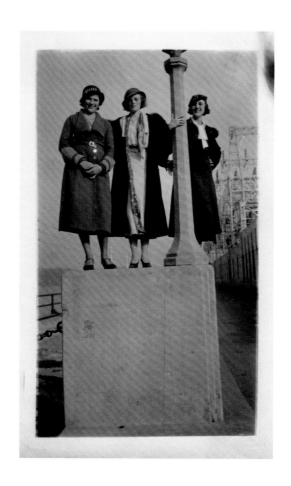

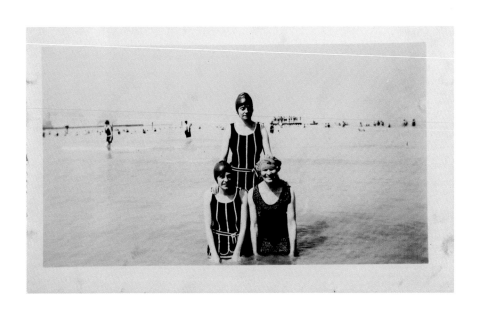

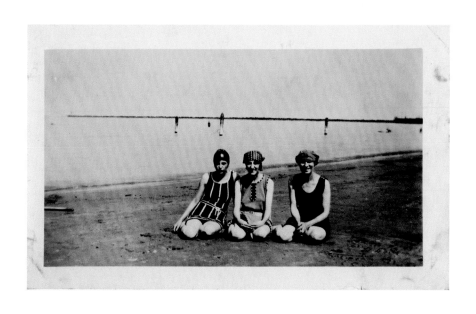

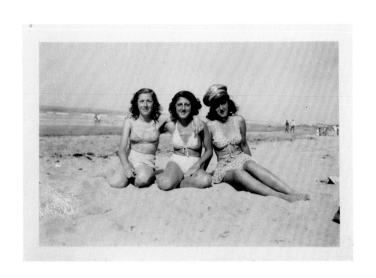

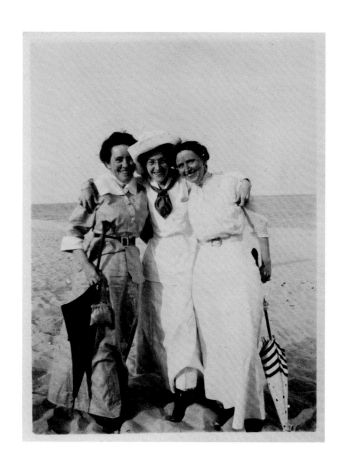

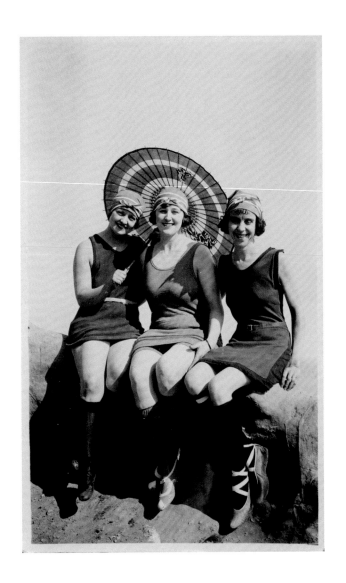

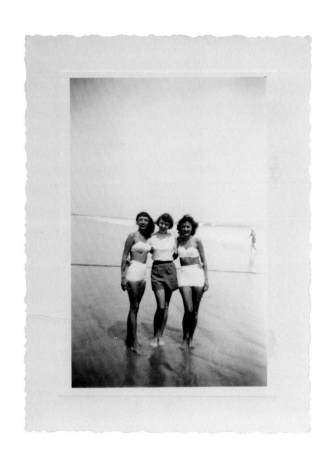

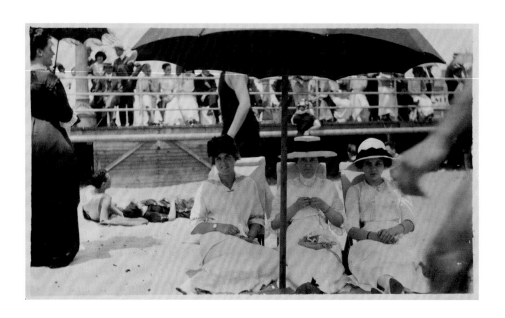

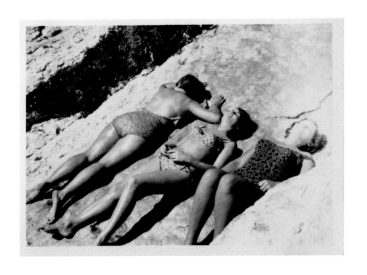

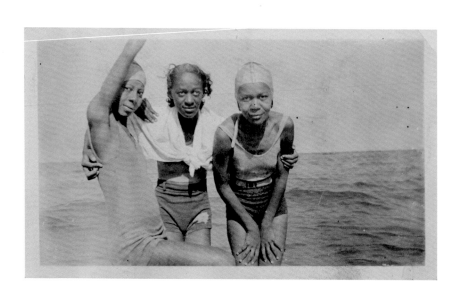

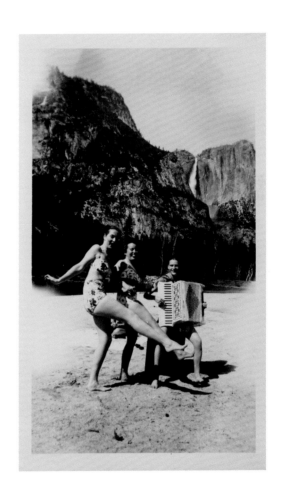

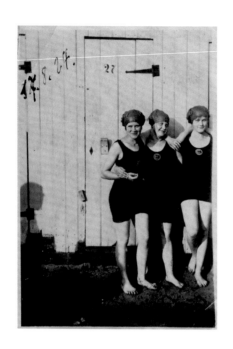

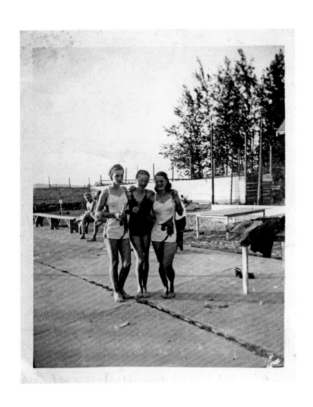

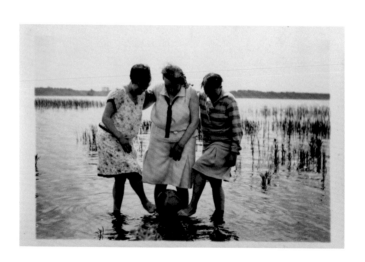

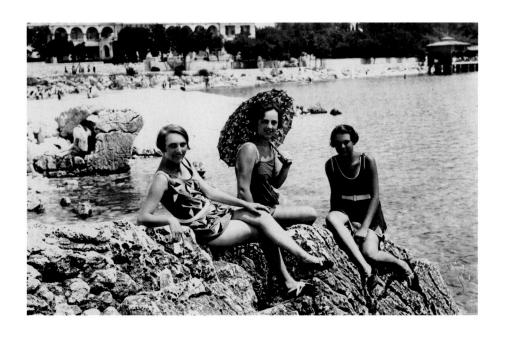

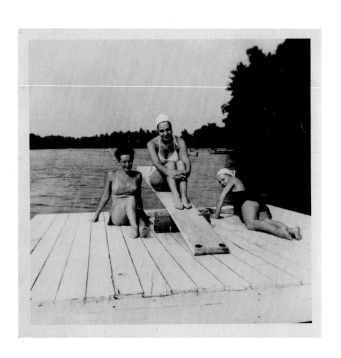

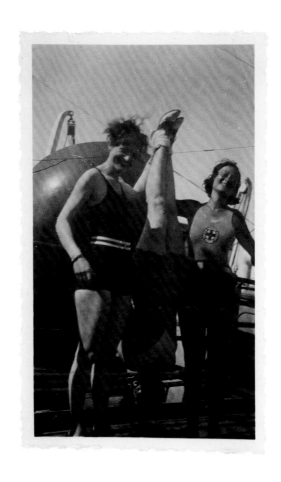

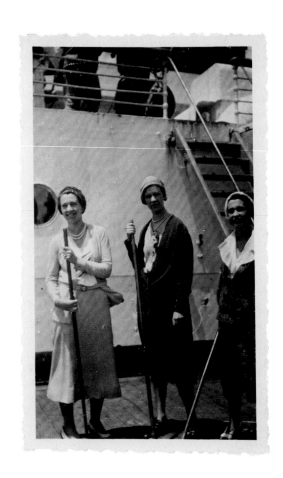

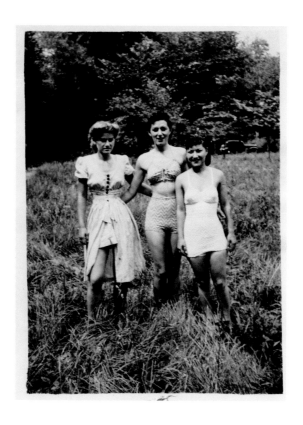

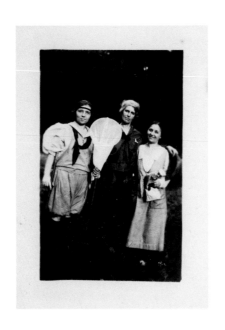

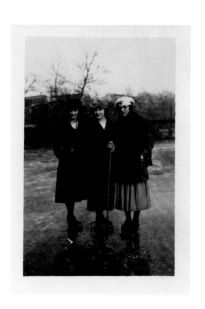

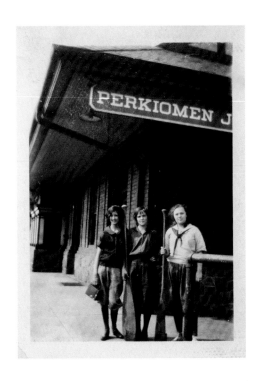

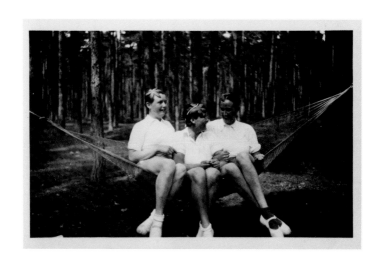

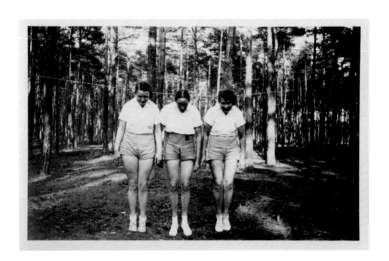

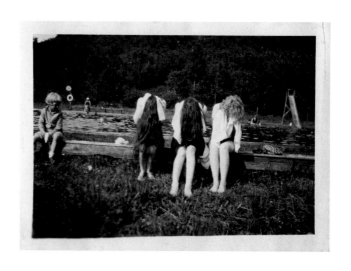

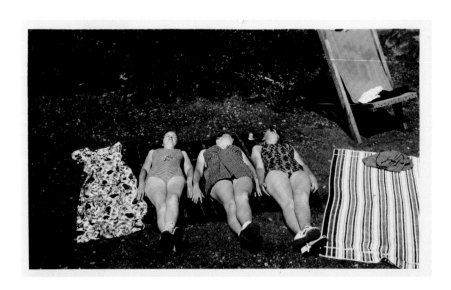

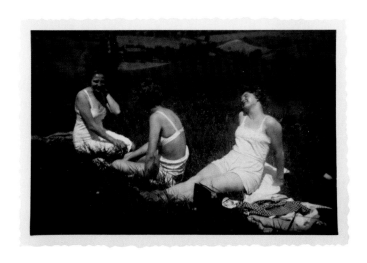

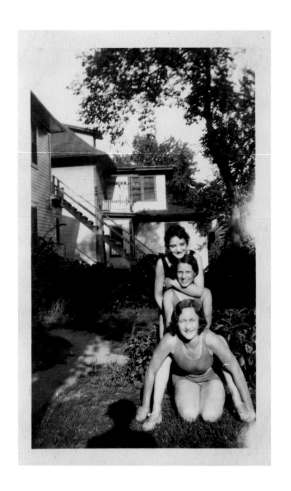

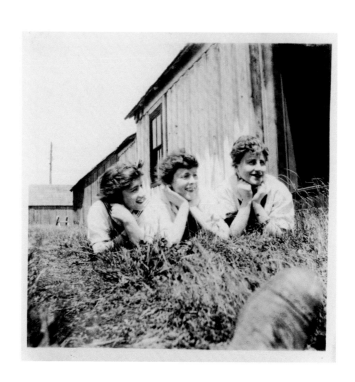

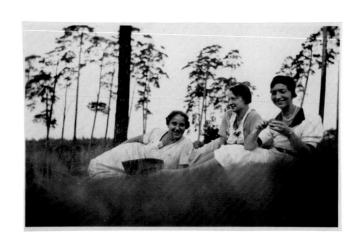

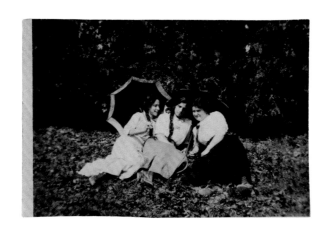

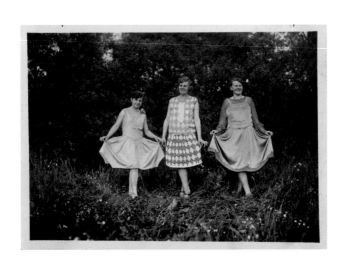

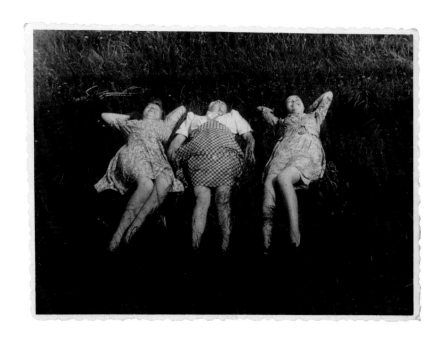

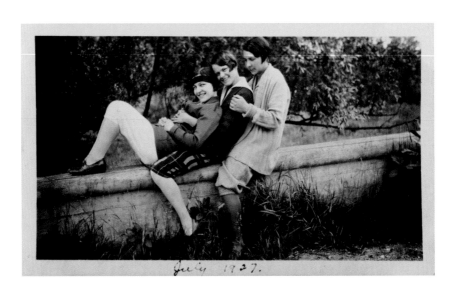

July 1927.

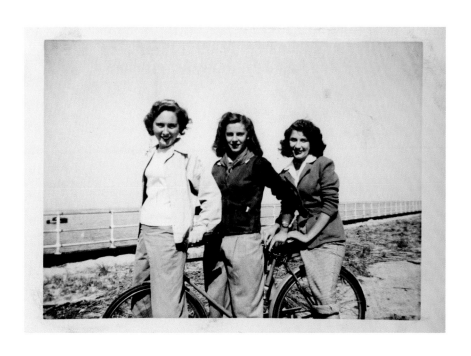

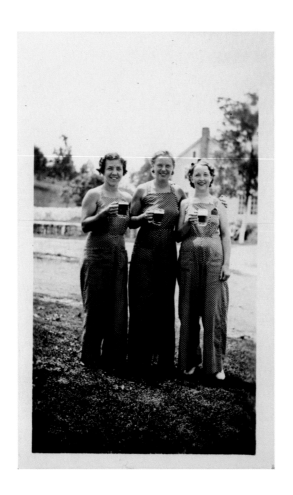

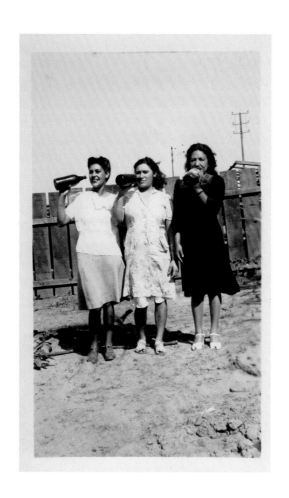

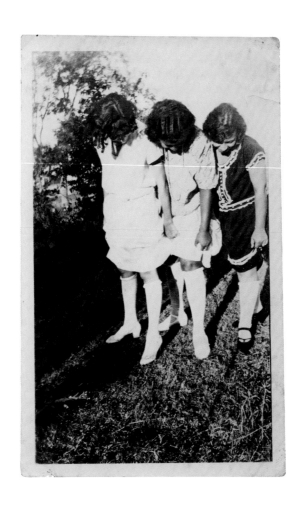

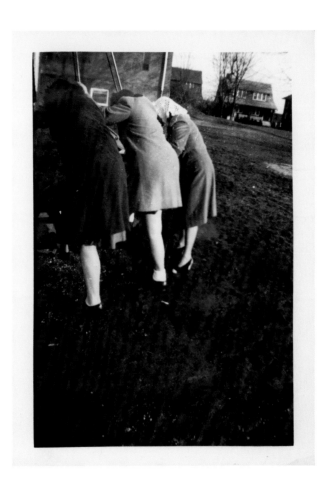

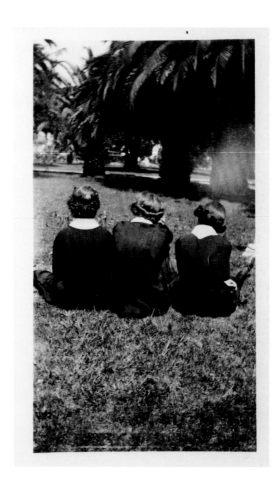

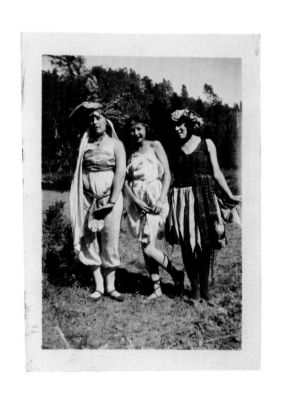

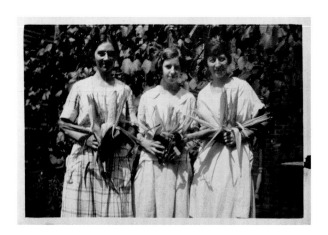

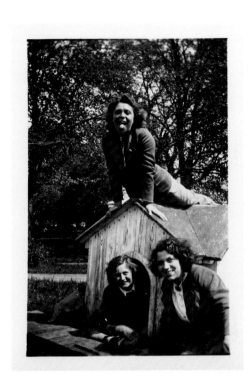

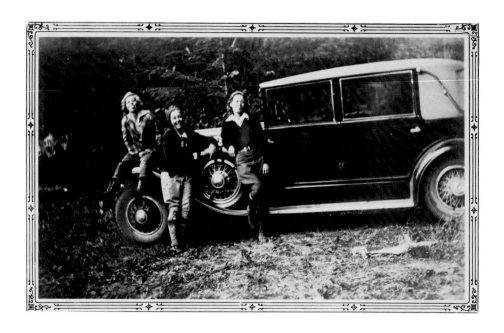

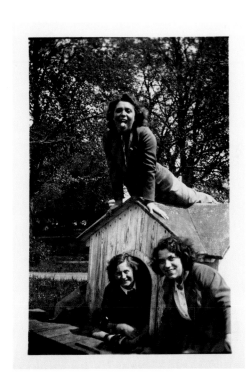

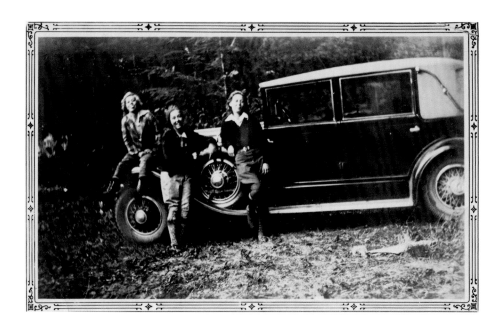

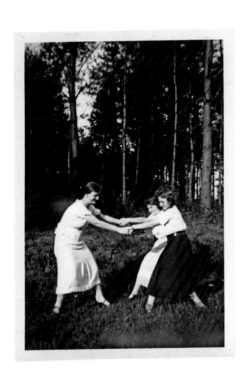

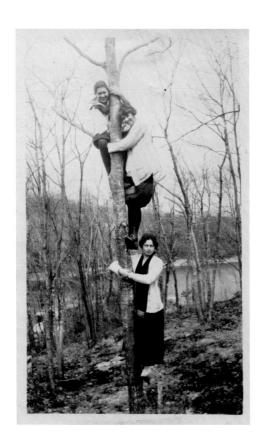

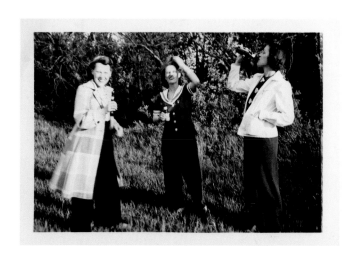

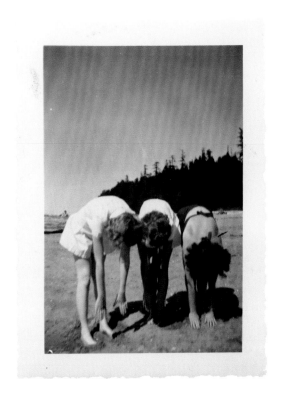

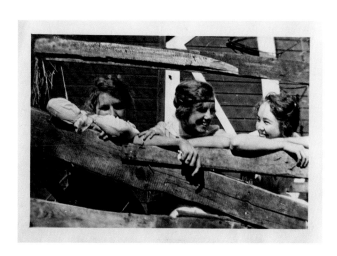

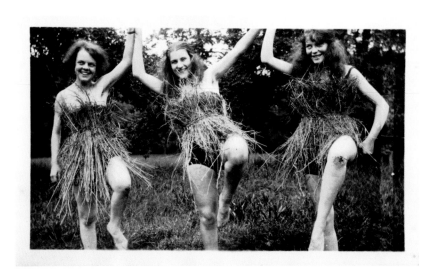

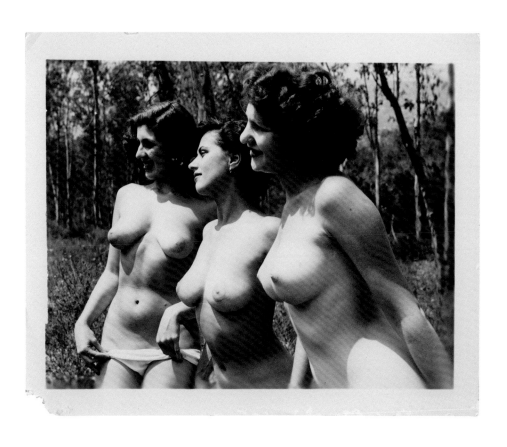

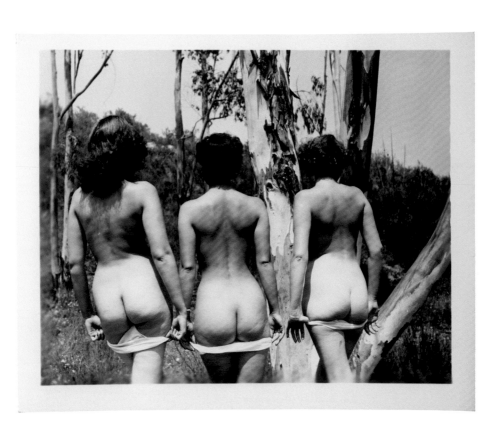

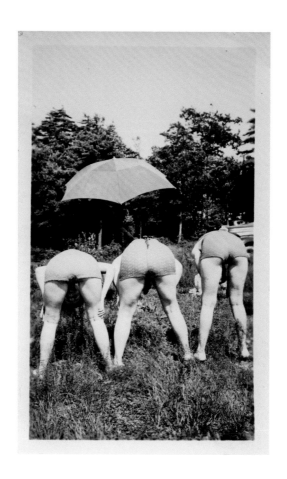

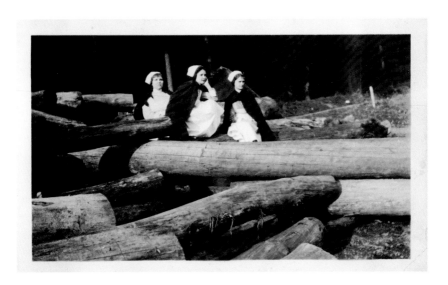

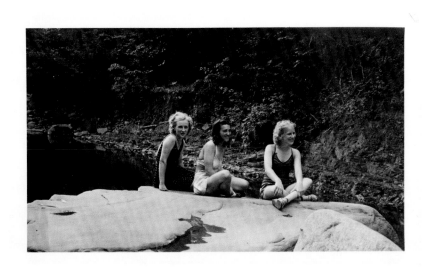

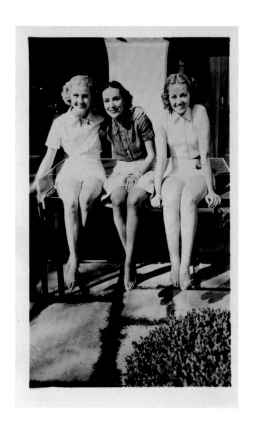

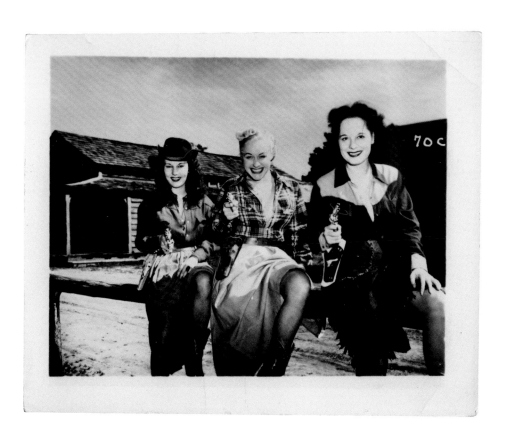

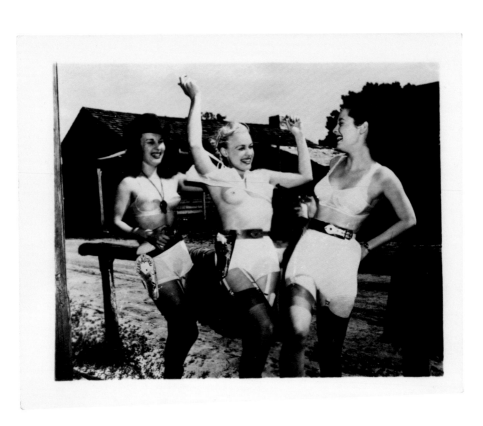

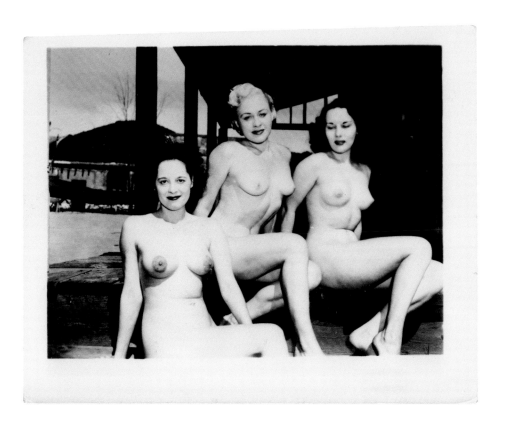

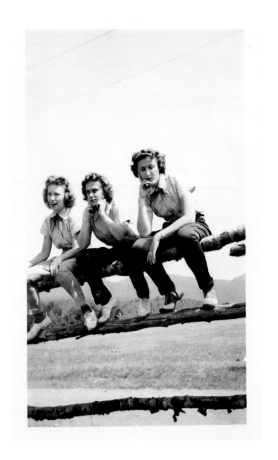

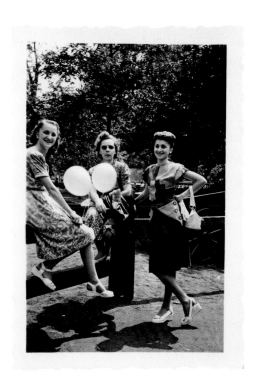

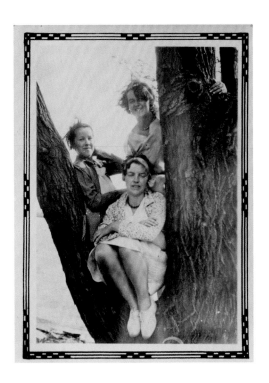

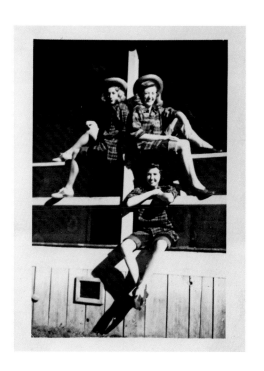

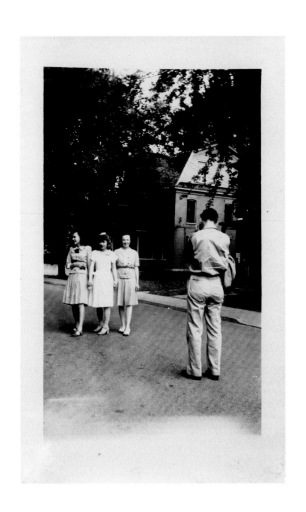

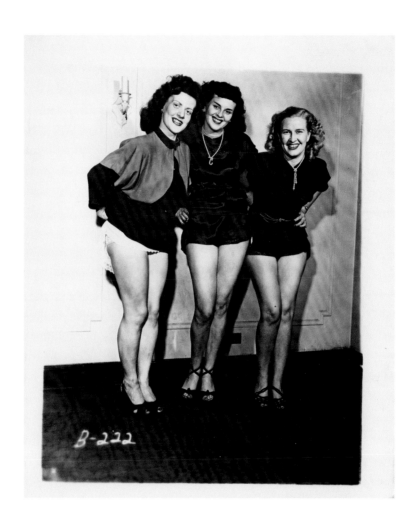

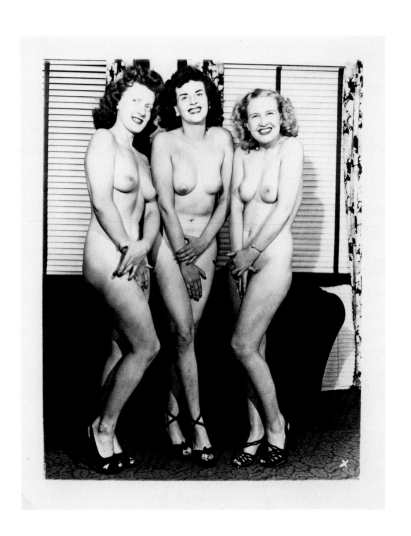

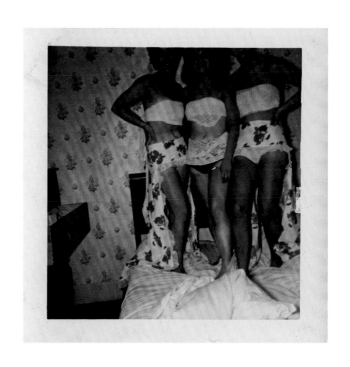

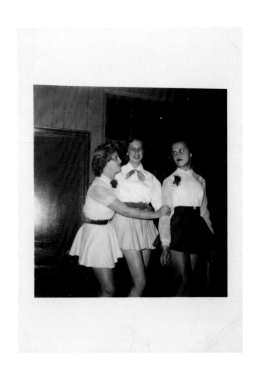

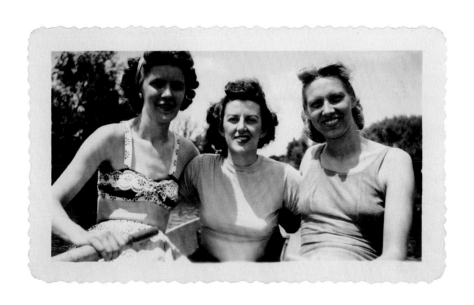

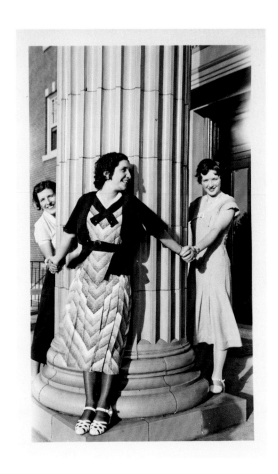

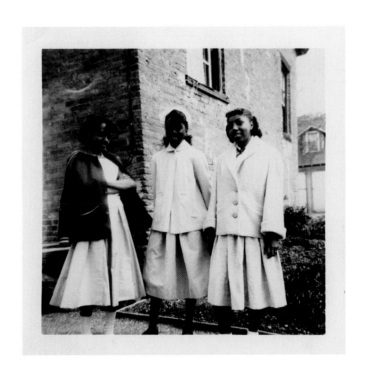

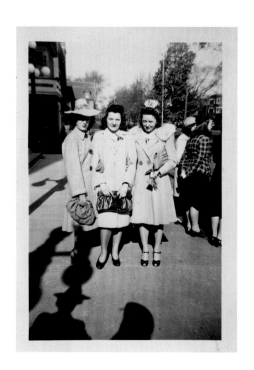

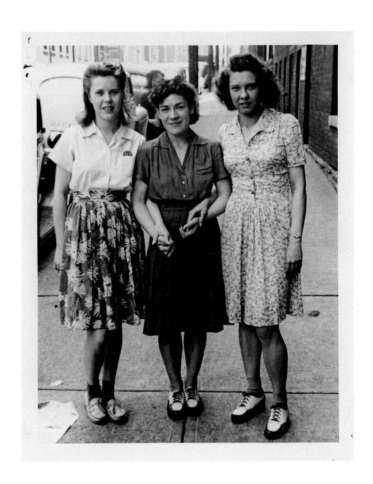

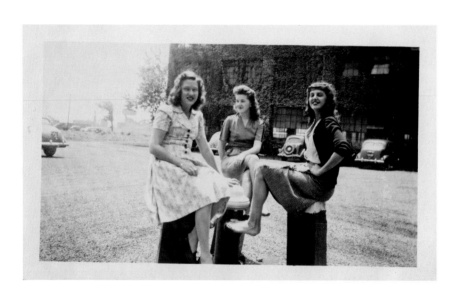

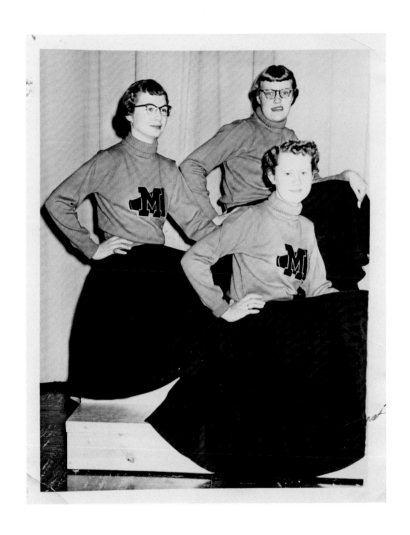

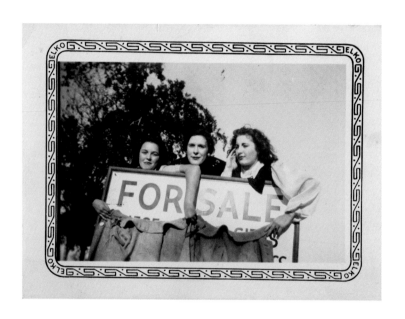

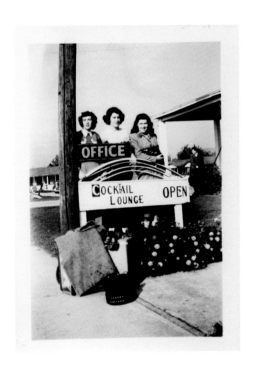

145

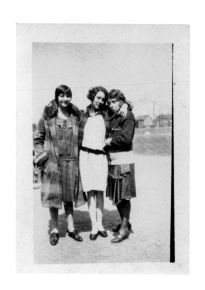

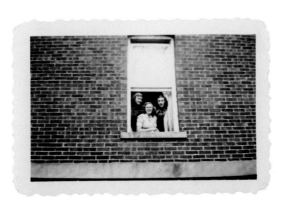

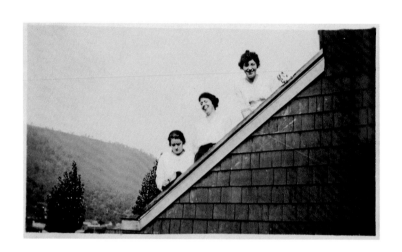

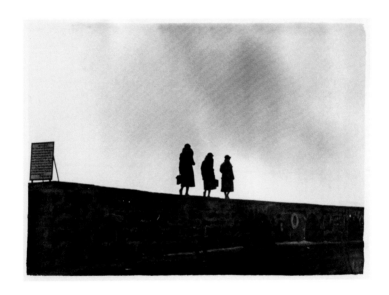

Checklist

Inscriptions follow page numbers, with stamped text indicated where present. Handwritten notations appear in quotation marks. Text that is illegible or tentatively transcribed is indicated in brackets. Asterisks indicate photographs printed as postcards. Estimated dates represent when the photograph is believed to have been taken, rather than printed. These dates were determined largely according to fashions and hairstyles with the assistance of Timothy A. Long, curator of costumes, Chicago History Museum, and Debra N. Mancoff, adjunct professor of art history at the School of the Art Institute of Chicago. All photographs are gifts of Peter J. Cohen to the Art Institute of Chicago.

14. c. 1920s *
15. c. 1940s
16. c. 1910s
17. c. 1920s
18. "In St. Joe," c. 1910s
19. "Look pleasant," c. 1910s [see also fig. 1]
20. c. 1910s
21. c. 1910s
22. "Mary Armstrong, Kathryn [illegible], Catharine Scharer," c. 1910s
23. c. 1920s
24. "May 1, 1910"
25. c. 1910s
26. c. 1930s
27. "Kay, Phoebe, Biba, Campus Day, October 1937"
28. c. 1930s
29. c. 1920s
30. "Three for a dollar," c. 1940s
31. c. 1940s
32. c. 1910s
33. "[R.E.S, ZEW., F.A.S., Edna H., DE Manwarren, E.S Posthill, E.W. Gere, TP. H. Brown]," c. 1910s
34. c. 1910s

35. c. 1940s
36. c. 1920s
37. "Ready for a walk," c. 1910s
38. c. 1940s
39. c. 1940s–1950s
40. c. 1950s
41. c. 1910s *
42. c. 1930s
43. "May 19, 1935"
44. c. 1930s
45. c. 1920s. Stamped: City Studio, Bristow, Oklahoma
46. c. 1930s. Stamped: Carhart's, "High Hat Finish," Aug 16 1937
47. c. 1910s
48. c. 1940s
49. c. 1920s
50. c. 1930s
51. c. 1940s
52. c. 1950s
53. c. 1940s
54. "So help me God this is what they look like." Stamped: Chattanooga Jun 8 1945 [rest of stamp illegible], c. 1940–45

55. "L. to R., Mary Alice Arrington, Me, Joy Bryan, my best friends, June 1947"

56. c. 1940s. Stamped: Passed by US Army Examiner 20438

57. c. 1930s

58. "August 9, 13" *

59. "Norma, Eva," c. 1930s

60. "Elsie Brinkmann, From Joseph Simmons, Marie, Nor., Els., taken by Joseph Simmons from Bayley," c. 1930s

61. "A picture of us girls in Uncle Bill's yard. It is the best one taken of us girls. Wanda, Verla and I," c. 1940s

62. c. 1950s

63. c. 1920s

64. c. 1940s

65. c. 1930s–1940s

66. c. 1940s

67. c. 1910s

68. c. 1940s

69. c. 1930s

70. c. 1920s

71. c. 1920s

72. "Raymonde, Anita, Solange, Fedala, F.M. August 45"

73. c. 1910s

74. c. 1920s *

75. c. 1940s. Stamped: Aug, Nevr-Fade

76. c. 1910s

77. c. 1950s

78. c. 1930s

79. c. 1930s

80. "In Bade [text illegible] am 31.8.1924"

81. c. 1940s

82. c. 1920s

83. c. 1930s *

84. c. 1940s

85. c. 1930s

86. c. 1920s

87. c. 1940s

88. c. 1920s

89. c. 1910s

90. "At the P. and R. station, Perkiomen Junction, A canoe trip, (Pussie, Babe, Brighty), 1923 At camp"

91. c. 1930s

92. c. 1930s

93. c. 1920s

94. "Alberta, Dot, [illegible]," c. 1930s. Stamped: Genuine Krystal Gloss, Guaranteed Forever, Jul—6 '38, Bear Photo Service

95. c. 1930s. Stamped: Rodenstock Berlin A2815

96. c. 1930s

97. c. 1910s–1920s

98. c. 1930s

99. c. 1910s

100. c. 1920s–1930s

101. "[Greta] und Ella Schwill," c. 1940s

102. "July 1927"

103. c. 1940s

104. c. 1930s

105. c. 1940s

106. c. 1920s

107. c. 1940s

108. c. 1920s–1930s

109. c. 1920s

110. c. 1920s

111. "Timmendorfer Strand, 1944"

112. "Charlotte, Marie and Margi," c. 1940s. Stamped: Wilson-Pain, Longview, Wash.

113. "[Text illegible], 16 September 1934"

114. c. 1910s

115. c. 1940s

116. c. 1940s

117. "Minnie O., Annie A, and myself in hay rack at [Robh] Patersons, 1916"